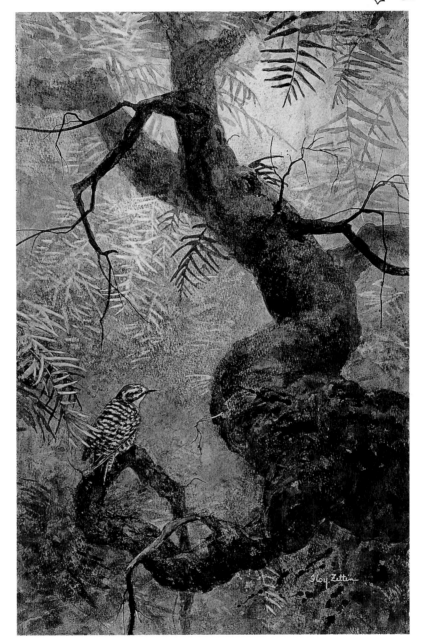

in the forest glade
hovering like incantations—
the twitter of birds

sweet reverence of little birds

~ an ensemble of watercolor, haiku and calligraphy ~

floy zittin, artist · patricia j. machmiller, haiku poet · martha dahlen, calligrapher

Sweet Reverence of Little Birds can be purchased at www.lulu.com

ISBN 978-0-557-38539-3

Wisdom begins with wonder.
—Socrates.

Through this book we hope to share with you our perspective on some of the wonders surrounding us in our daily life. May they bring delight, reverence—and perhaps, even, a little wisdom.

forest solitude—
the fiddlehead ferns
uncurling

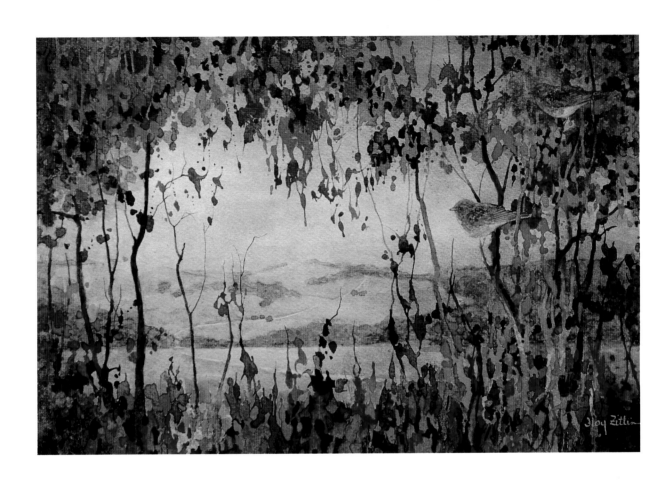

secretly
where chokecherries bloom
daydreaming

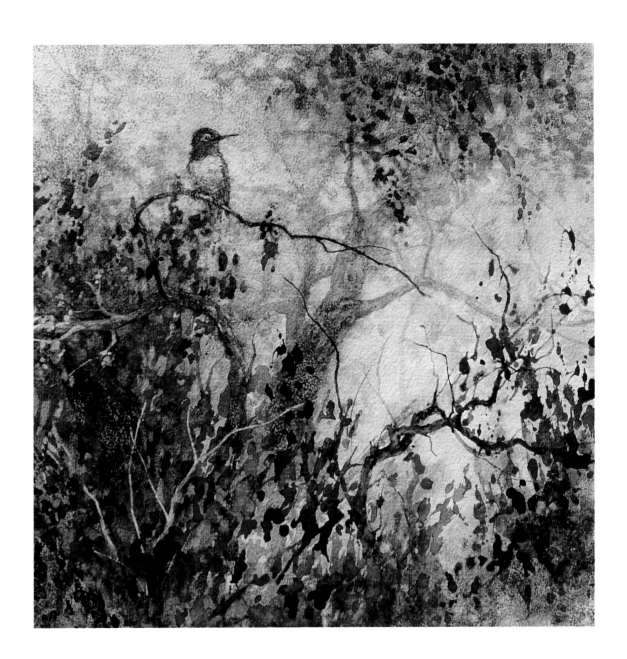

tucked in her backpack
the letter she didn't send—
spring melancholy

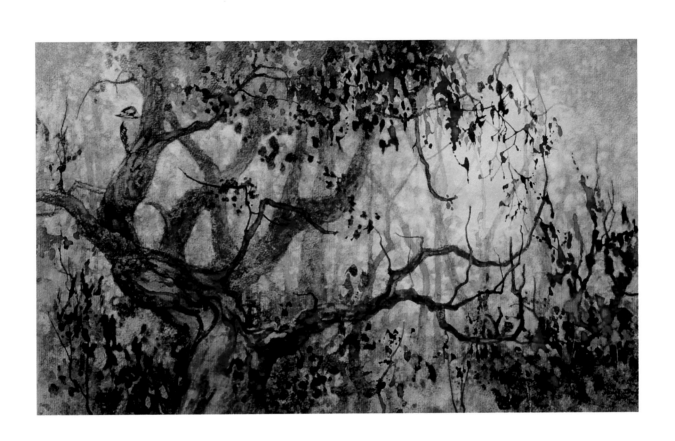

who said *all the new*
thinking is like all the old ?
young leaves in sunlight

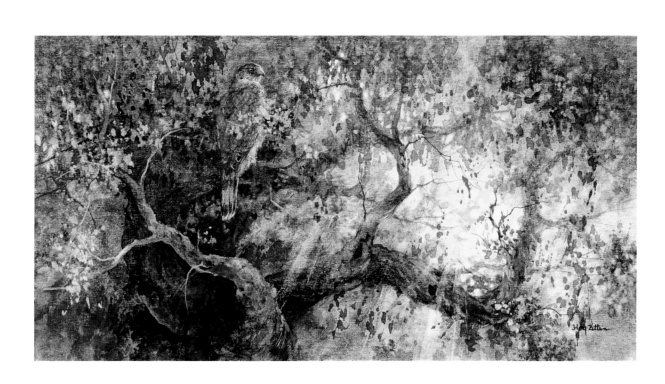

lingering day —
the bayou, even, seems
to be listening

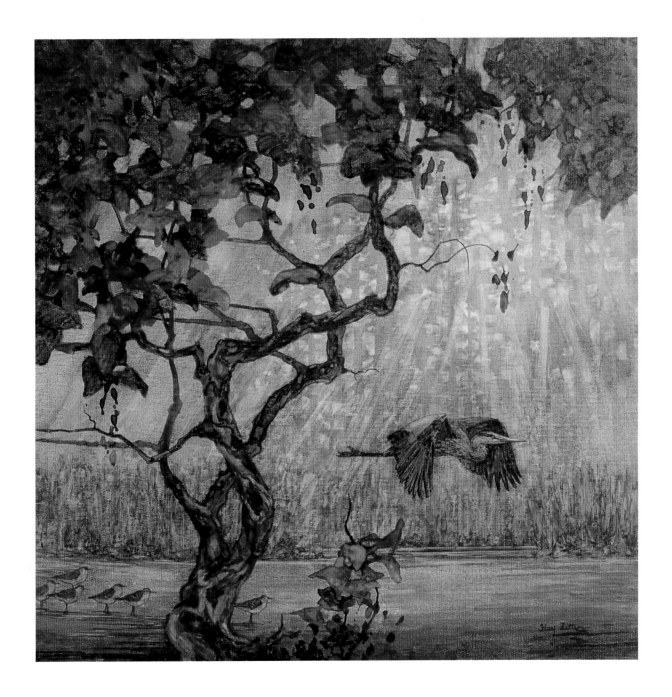

morning coolness
wraps each forest thing in
quiet

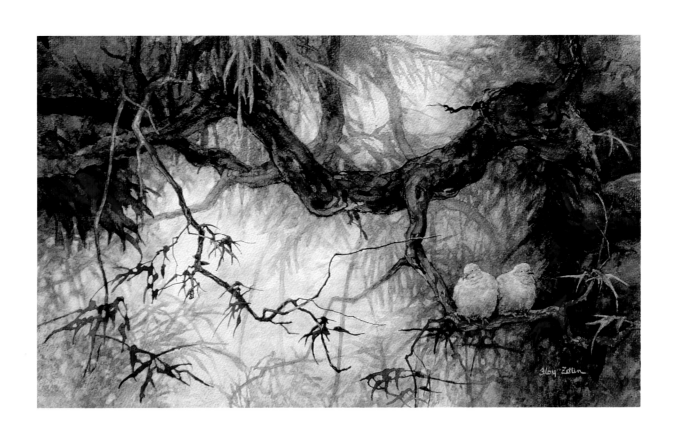

green-leaf shade —
this wanting to know what now
can never be known

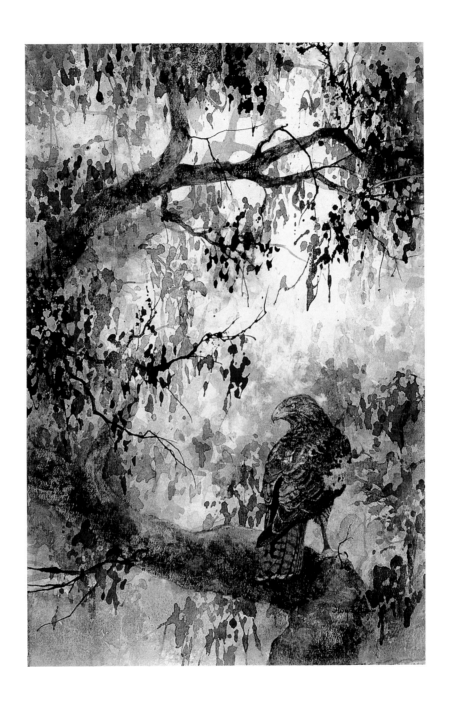

summer lake —
suddenly only spreading
rings of golden light

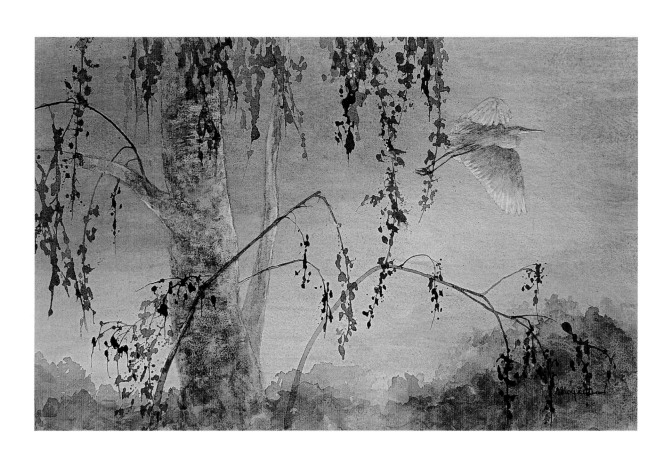

this short night is ending —
sweet, the reverence of
the little birds

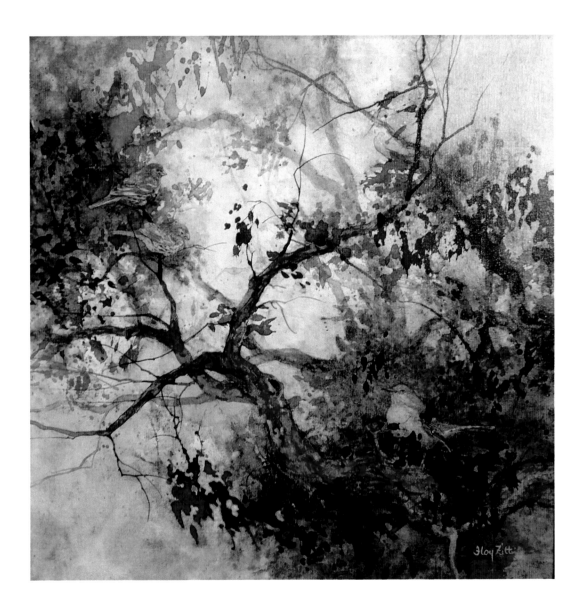

far-away voices
fall in and out of hearing—
green-leafed wind

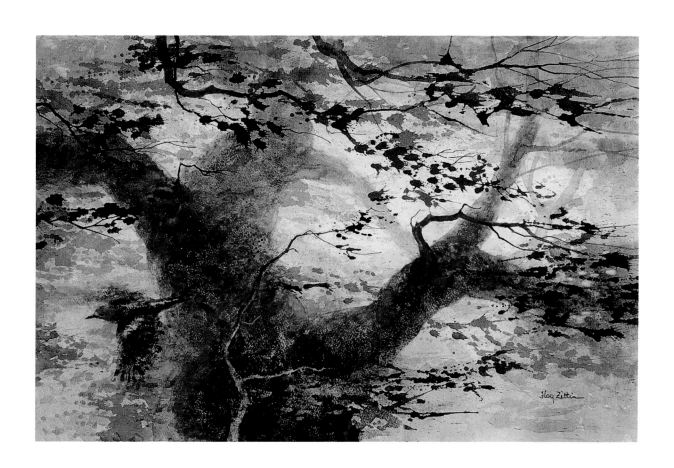

dog days of August —
we linger in the twilight
waiting for Godot

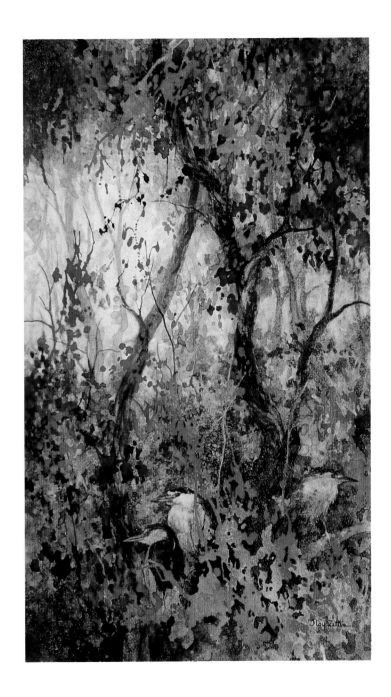

approach of autumn—
poised, the seeker peers into
the shifting light

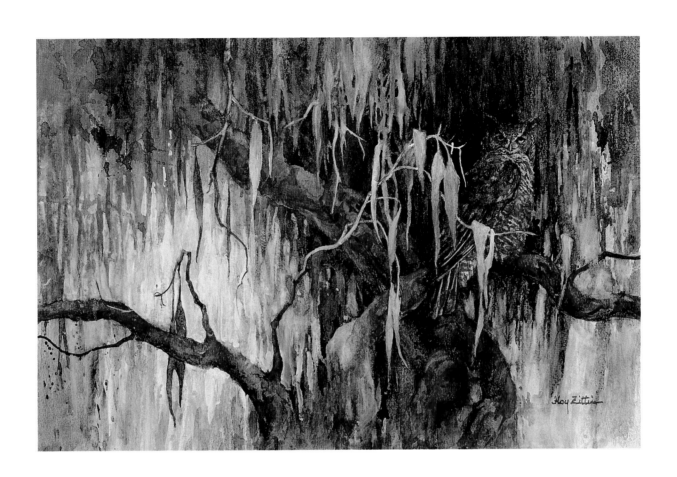

summer ends: birds call
first one ear, then the other
one... the other...

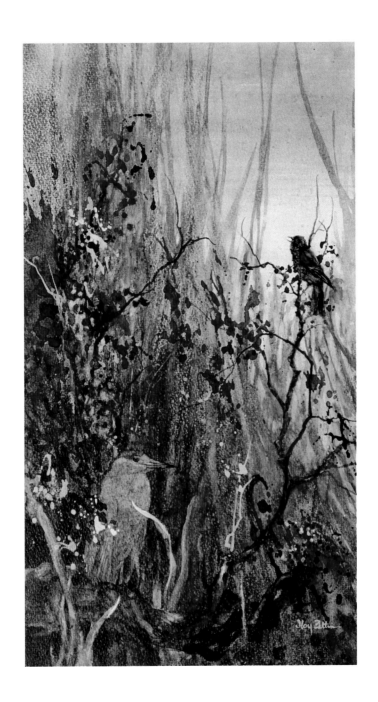

lying in the grass
chin propped in her hands —
this dewdrop world

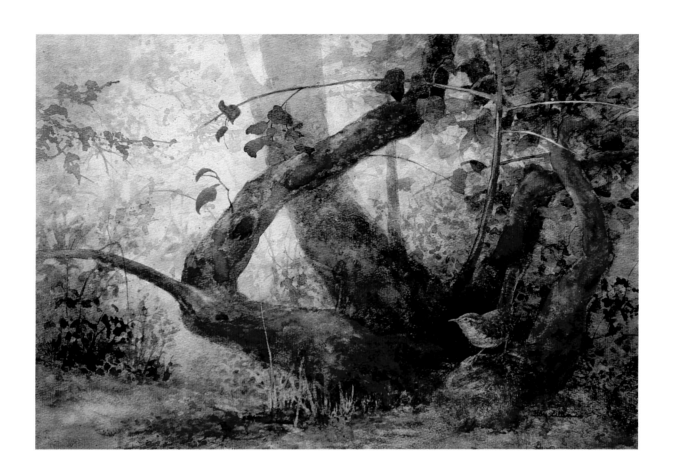

chatter of finches —
in their hustle-bustle
dry stalks rattling

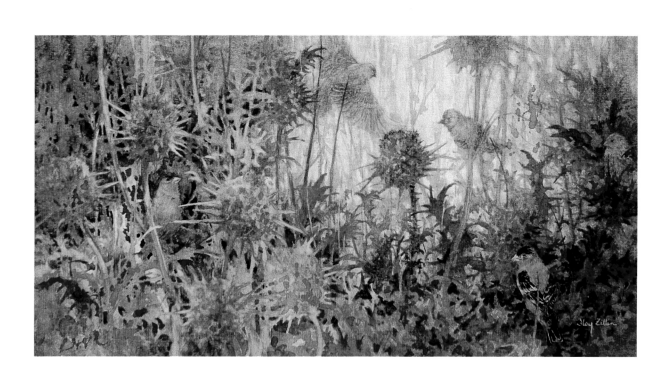

Indian summer —
suddenly a message
from out of the blue

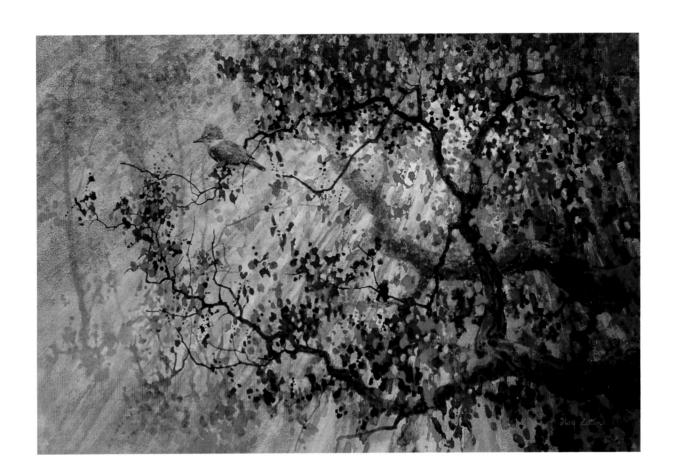

in the fairy tale
there is always a stranger—
autumn loneliness

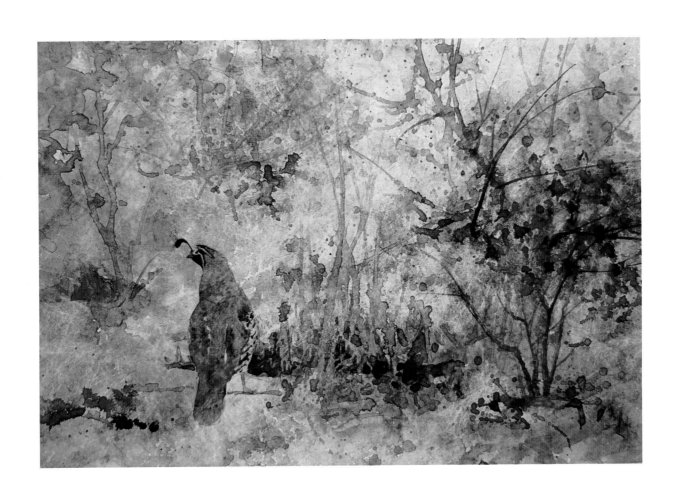

in tree bowers fog
seemingly comes from nowhere
— a moving stillness

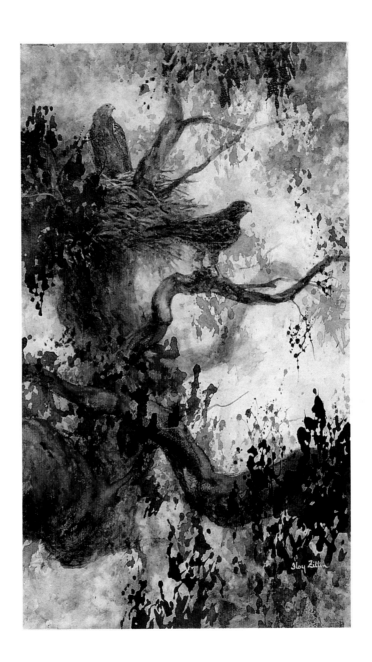

mysterious
how thoughts come and go—
winter wind

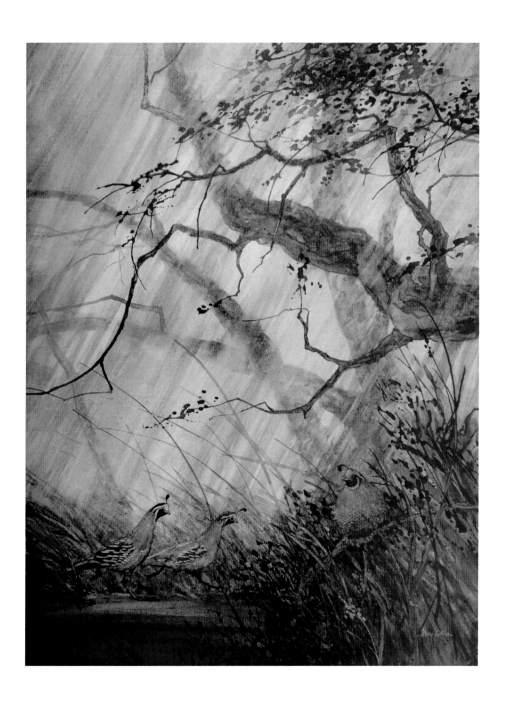

calligraphy—
the twists and turns buried
in ancient mist

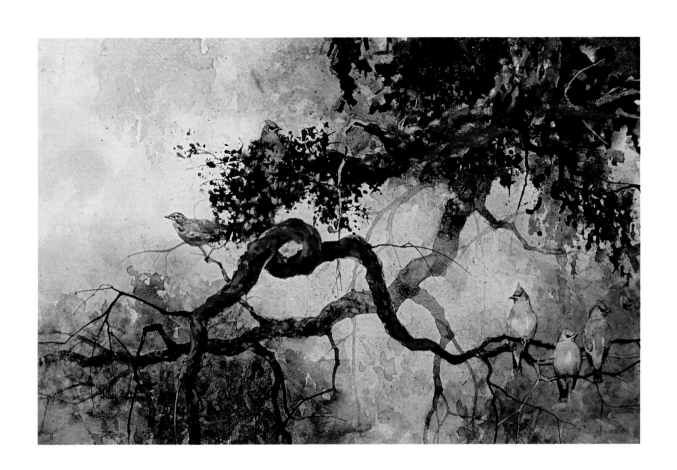

The Collaborators

Floy Zittin is an accomplished watercolor artist and teacher. Her training as a natural science illustrator means that, technically, she knows her birds well, while her brushwork has a breathtaking dynamic quality, not unlike that of Asian brush painting. www.floyzittin.com

Patricia J. Machmiller is an award-winning haiku poet and teacher. Trained as a chemist, now poet and painter, the shift in perspective has given her a keen sensitivity to the changing moods of ordinary people in our magical world. www.patriciajmachmiller.com

Martha Dahlen is a botanist, writer, and calligrapher. She spent two decades in Hong Kong where she studied both English and Chinese writing. Here, the unevenness of the marks made by a Western tool, a Sharpie pen, on rice paper conveys the charm of both haiku and birds. www.mdahlen.com

The characters, in order of appearance, with the first line of the accompanying haiku are:

forest solitude. Nuttall's Woodpecker
in the forest glade. Western Bluebirds
secretly. Anna's Hummingbird
tucked in her backpack. Downy Woodpecker
who said. Cooper's Hawk
lingering day. Great Blue Heron
morning coolness. Mourning Doves
green-leaf shade.Red-tailed Hawk
summer lake. Great Egret
this short night. House Finches & Mockingbird
far-away voices.Red-breasted Sapsucker
dog days of August.Black-crowned Night-Herons
approach of autumn. Great Horned Owl
summer ends. Night-Heron & Red-winged Blackbird
chatter of finches. American & Lesser Goldfinches
Indian summer.Belted Kingfisher
in the fairy tale.California Quail
in tree bowers. Swainson's Hawk
mysterious.California Quail
calligraphy.Cedar Waxwings & American Robin